T0386688

Bon
Mots

Diana
Vreeland

RIZZOLI
NEW YORK

New York Paris London Milan

Words
of Wisdom
from the
Empress
of Fashion

Bon
Mots

Diana
Vreeland

Edited by
Alexander Vreeland

with Illustrations by
Luke Edward Hall

Over the years, I've met many people who have told me that their lives were significantly affected by my grandmother. I've come to the conclusion that it is her words that resonate with them. As she said when her book *DV* was first published in 1984, "I didn't write it; I spoke it." She didn't sit down and write notes or letters; she called her assistant into her office to record what she had to say. Her enthusiasm, vision, and *bon mots* have encouraged many generations to do their best, most creative work.

Bon mots is French for "well-chosen words"—phrases to live by. Though my grandmother is known for being an editor, she also possessed a declarative power to launch new styles, new trends, and new designers, thereby becoming an oracle of fashion. When she was fourteen she proclaimed in her journal, *"I shall be that girl!"* She became the girl she had envisioned and went on to re-create everything she touched during her long career at *Harper's Bazaar*, *Vogue*, and the Costume Institute at the Metropolitan Museum of Art.

This book is a compilation of some of my favorite sentences and passages that she ever said and wrote. We scoured her files, including the archives at the Metropolitan Museum of Art, Condé Nast, and the New York Public Library, and went over early drafts of her books as well as the tapes that created them.

The quotes in this book contain essential wisdom and insight into how to live. It starts with a dream, but then there must be the courage and discipline to believe in oneself and to actualize that dream.

This is a handbook that is meant to travel with you, that you return to, continually finding new inspiration.

— Alexander Vreeland, June 30, 2019

Allure holds you, doesn't it?
Whether a gaze or a glance in the street
or a face in the crowd or someone sitting
opposite you at lunch—you are held.

Allure...
is something around
you, like a perfume,
like a scent. It's like
memory—it pervades.

1

Allure

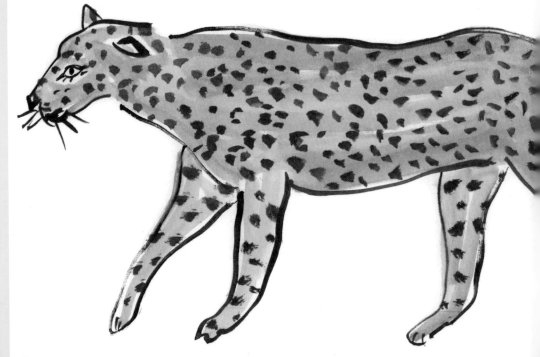

The world
without a leopard!
I mean,
who would
want to be here?

I think
the gondola and
the horse
are the two
most beautiful
things in
the world.

I'm mad about horses and the world of animals because they, of course, have more style than any human being that's ever lived.

Elegance is innate.

It has nothing to do with

being well dressed.

It's a quality possessed

by certain thoughts

and certain animals.

Gazelles, I suppose, have elegance

with their tiny heads and satiny coats

and their little winning ways.

The trouble is that women
could make so much more
of themselves.
I like the artificial.
Not that I think everyone
should go around
like a Japanese Kabuki character
like me,
but I do think
women copy each other
too much.

A little bad taste
is like a nice splash
of paprika.
And we all need
a splash of bad taste.
No taste is what
I am against.

I think things must have rhythm
and meaning, and a sense of love
and beauty and pizzazz and passion.

To me,

the neck

is the beginning

and the end

of looking

like anybody.

Do you notice any scent on me now?
Don't come any closer—if you have to sniff
like a hound, it's not enough!

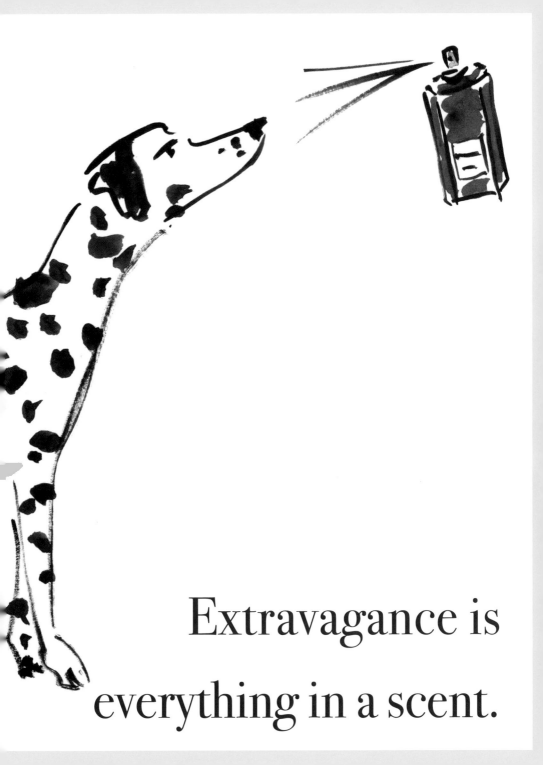

Extravagance is everything in a scent.

The great days are now! I never want to hear about the past again.

Don't think you were born too late. Everyone has that illusion.
The only problem is if you think too late.

2

Never Young, Never Old

I am not speaking

of what age you are.

I am talking about

the bumps on your body,

the length of your throat,

and the condition of your legs.

One can be any age if one is,

so to speak, a figure of youth,

all of which comes from a spirit

and continual self-education.

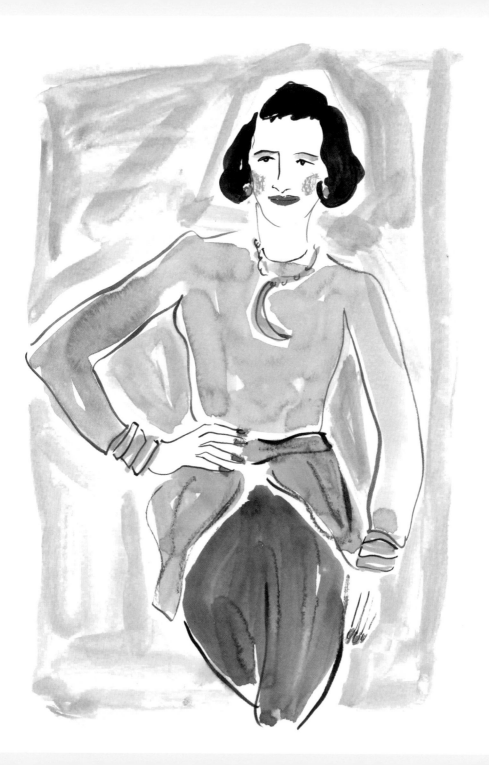

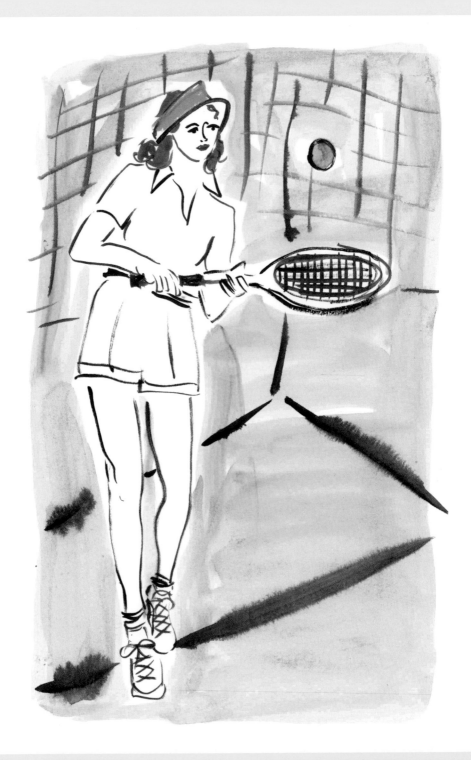

Remember, activity is what keeps you young.

I've never felt any age
in my life—never young,
never old, never in-between,
never anything.

You have to keep up
with the *times*.
You have to be interested
in what's *happening*,
in what is *contemporary*,
in order to keep life
meaningful and exciting.
Living in the past
is the quickest way to age.

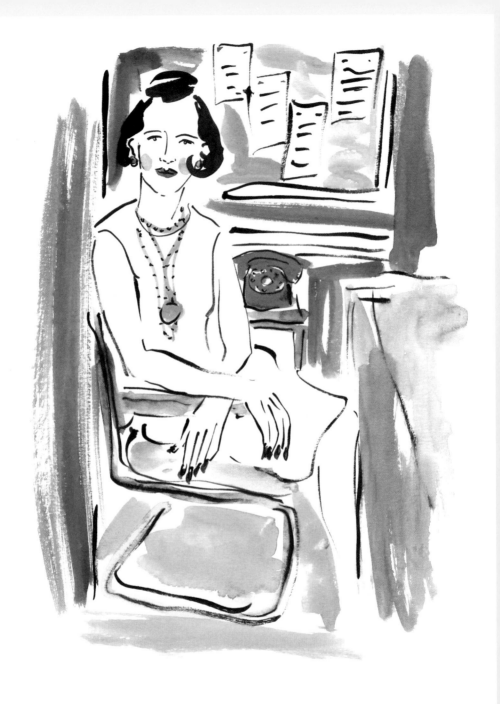

People say elegance is dead. They used to say the waist is dead, the woman is dead. Everything's alive— nothing dies!

I never want
to know anyone's age,
but I always
want to know
where they were born.
It tells you so much.

**The quickest way
to show your age
is to try to look young.**

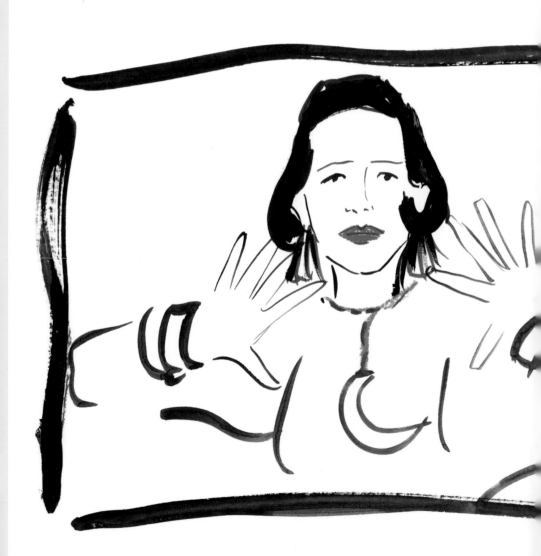

I think when
you're young,
you should be
a lot with yourself
and your sufferings.
Then one day
you get out
where the sun shines
and the rain rains
and the snow snows
and it all comes together.

Lighting is everything in a color.

Black is the hardest color in the world to get right— except for gray.

The Color of the Inside of a Pearl

3

Yellow!
You don't
understand
yellow!
Only Matisse
and I
understand
yellow!

Pauline de Rothschild
lived in a house where
everyone used to argue about
what color she'd had the
drawing room walls painted.
I can tell you what it was:
It was a light gun-metal gray—
the color of the inside of a pearl.

I would like it
in a most vivid *violet-purple*
that you can get for me.
That is to say *violet*
with red in it—
vivid and bright.
Blue-purple goes
very black at night and
looks like an old-fashioned
demi-mourning.

– Letter to Madame Grès, 28 October 1974

It is important that you all know
that this photo shoot is going to be
in the ancient cities of Iran
where blue is everywhere.
Therefore, please order everything
in *marvelous* blues, *vivid* blues,
mixed blues, *printed* blues—
blue all the way!
An occasional dash of color could
be bright yellow but let's keep to blue
because of the sky
and the marvelous tiling everywhere.

– Memo to Vogue *staff, 30 June 1969*

I love the names
of men's clothes
of the Regency period:
buff, sand, fawn,
and don't forget *snuff!*
My God, there were words
in those days!
Where is *snuff* today?

All my life I've pursued the perfect red—I can never get painters to mix it for me. It's exactly as if I'd said, "I want Rococo with a spot of Gothic in it and a bit of Buddhist temple." They have no idea what I'm *talking* about!

Actually, pale pink salmon is the *only* color I cannot *abide*. Although naturally, I adore pink. I love the pale Persian pinks of the little carnations of Provence, Schiaparelli's pink, the pink of the Incas. And though it's so *vieux jeu* I can hardly bear to repeat it— pink *is* the navy blue of India.

I think it is *essential* that we have a very good example of what you call indigo blue, as colors change from light to light and country to country. We have no blue whatsoever in this country because we haven't very much blue light—*that is to say, from heaven.* Therefore, we leave it to you to send us a quite large swatch of indigo blue in any type of fabric that you choose, so that it can be divided between two painters here in order to get this color *absolutely* correct.

I thought I would also have a most beautiful and marvelous jade, a shrimp pink, a shell pink, and a sunset pink.

Also, I think the green should be wonderfully shaded from pale through a bit stronger through to *really strong* jades, because green is such a difficult color to get.

I also think any swatch of fabric—anything—such as lavenders, orchids, moonlit violets, etc., that we can use that has been created in the light of India is so much more valuable than any other way of getting a color.

– Letter to Marthand Singh, regarding the preparation for the Costumes of Royal India *exhibit at the Costume Institute, 22 April 1985*

I loathe red with any
orange in it—
although curiously enough,
I also loathe orange
without red in it.
When I say "orange,"
I don't mean yellow orange,
I mean red orange—
the orange of
Bakst and Diaghilev,
the orange that
changed the century.

About the best red is the color of a child's cap in any Renaissance portrait.

Red is the great clarifier—bright, cleansing, and revealing. It makes all other colors beautiful. I can't imagine becoming bored with red—it would be like becoming bored with the person you love.

I'm accused of exaggeration. I
think everything is exaggerated,
much more exaggerated than
people like to think about. I'm for
exaggeration, but I don't call it
that. I call it "the facts of the case."

I'm a great believer
in vulgarity—
if it's got vitality.
It's a very important
ingredient in life.
I think we could use more of it.

Creative Thinking

4

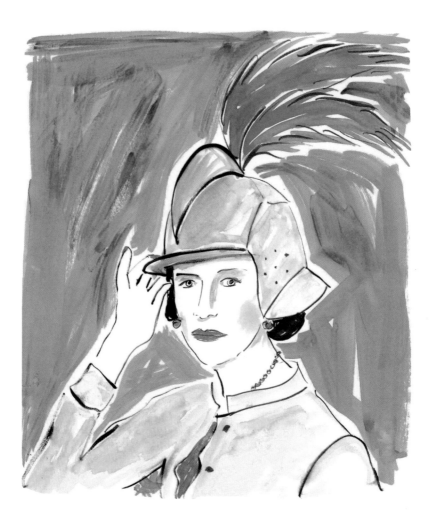

Oh, I am mad about armor. Mad about it! I love the way it's put together. I love the helmet with the feather out the back.

I think it's a
great mistake
to cater to popularity.
Where's the style in it?

Anybody who does anything really, really well is way, way ahead of everybody else.

A good photograph
was never
what I was looking for.
I like to have a point.
I had to have a point
or I didn't have a picture.
That is what I always found
so fascinating
in paparazzi pictures.
They catch something
unintended—on the wing—
they get that thing.
It's the revelation of personality.

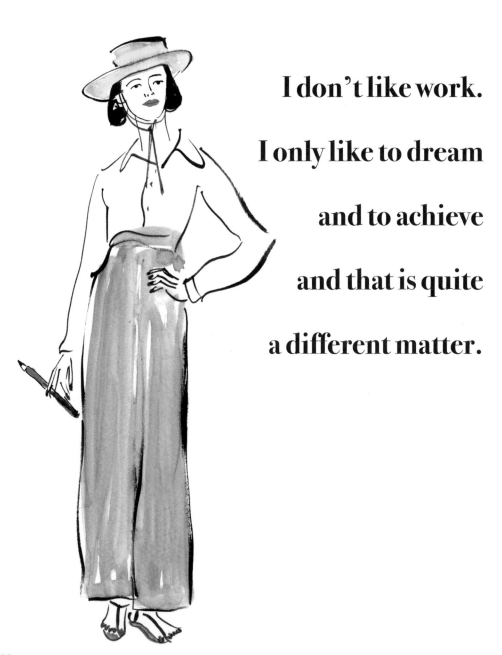

I don't like work. I only like to dream and to achieve and that is quite a different matter.

Everything interesting is
a little extreme.
Understatement is just
pitter-patter.

Don't give people
what they want.
Give them what they never
dreamed they wanted.

Well, you have to have a dream. And if you're going out to buy a pair of bedroom slippers, *you have to have a dream of what you want.* And as I can never find a pair of bedroom slippers I can get into, I've only got the dream.

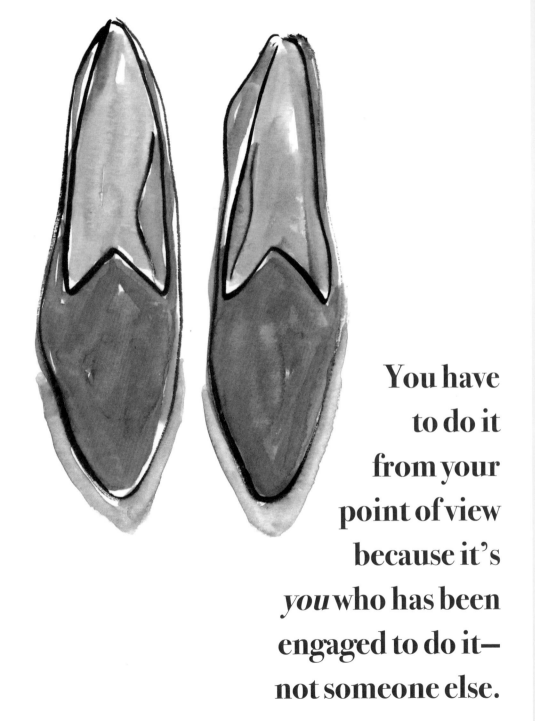

You have to do it from your point of view because it's *you* who has been engaged to do it— not someone else.

How can life be
possible
without fantasy?

I loathe nostalgia.

I love people who have ideas.

If you compete,
you're looking left and right
and it holds you back.
I knew that no one knew
what I knew and
I didn't question it.

I never *have* a meeting, never *attend* a meeting, wouldn't know what to *do* with a meeting. I just have a big black desk for myself.

I'm looking for the suggestion of something I've never seen.

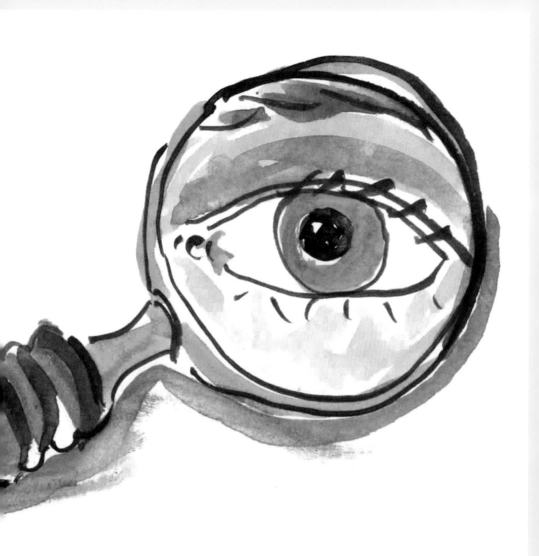

Style—all
who have it
share one thing:
originality.

I think fashion
must be the
most intoxicating
release from
the banality
of the world.

5

Fashion and Style

I was always mad about clothes. You don't get born in Paris to forget about clothes for five minutes.

Don't be afraid of your clothes being too classic, as those are the hardest clothes in the world to get.

– Letter to Hubert de Givenchy, 1 March 1974

Where
would fashion
be without literature?

It has always been
my firm belief
that fashion is
only made
for youth
and everyone else
has to compromise.

I mean,

a new dress

doesn't get you anywhere;

it's the life you're

living in the dress.

A pair of shoes
should be kept
as if they
were diamonds.

Elegance is
everything
in a shoe.

Footnotes

Everyone should have a shoemaker they go to, the way they go to their doctor.

I hope to God I die
in a town with
a good tailor,
a good shoemaker,
and someone
who's interested
in a little
quelque chose d'autre–
but all I really
care about
is that shoemaker.

Unshined
shoes
are the
end of
civilization.

People should respect their shoes, not take out their anger by blustering about in them.

Children, naturally,
are terribly aware of feet.
They're closer to them.

To enjoy a fire doesn't mean the whole room has to be in flames.

When I discovered dancing, I learned to dream.

7

Getting Around Corners

Dear Miss Gibbs,

I am answering your questions literally though one's main difficulties are so personal that I of course trust you that these answers are kept totally without name.

Being a very sound sleeper and with no sleep problems, this has been my largest and most difficult problem.

> 1. Did you ever find anything difficult for you to do?
> *Getting up when called, which has always been at 7:45.*
> 2. Did you work at it, or simply ignore it?
> *I simply got up. I had to or I would have lost my job.*
> 3. How did it make you feel?
> *That I was having great difficulty and could have slept many more hours.*
> 4. The problem—do you still have difficulty with it?
> *The problem has been identical from the time I started working until the present. It has never lessened.*

This has been my only problem, as I wake up filled with ideas and inspirations. All these feelings must be sorted out, channeled into reality and practical rhythms, and by nine I hope to have a working mind. I realize that anything not accomplished between nine and ten o'clock does not take place that day. The average business man would make this between eight and nine a.m.

Very sincerely yours, Diana Vreeland

– Response to a student at Bennett College, 23 October 1973

You know the greatest
thing is passion.
Without it,
what have you got?
I mean, if you love
someone you can love
them as much as
you can love them,
but if it isn't a passion,
it isn't burning,
it isn't on fire—
you haven't lived.

Have I told you

that I think

water is God's tranquilizer?

One thing I hold

against Americans

is that they have

no flair for rain.

They seem unsettled by it.

They take it as an assault.

The idea must be that you learn from the exaggeration.

I hate
the word
glamorous
but it does
help you
get around
corners.

The loss of a loved one
is sometimes like
losing part of yourself.
The only way to compensate
is to work at something
that will give you a sense
of accomplishment
and make you begin
to feel whole again.

Particularly in this
present world,
children most urgently
need to be surrounded
by all the warmth,
all the love,
and all the protection
that you can muster for them.
Children should be,
more than ever,
instilled with a sense
of individuality.
It is hard to convince
young children
that they are individuals and
not just another straw in the wind.

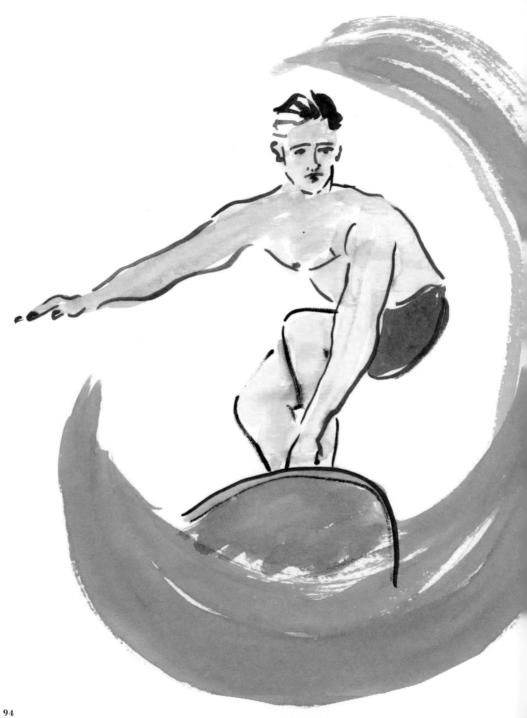

Surfing! I do think that surfing

would be the most beautiful thing

in the world to do. I do really

believe that. I used to go down to

Malibu Beach; I'd stay until midnight,

wrapped up in shawls. They were

in rubber suits and I could just

catch sight of them on the top of

the waves in the light of the moon.

I could watch forever! Forever.

I believe in the rare,
the extravagant, the utmost
of everything. I don't believe
in the middle of the road
because I don't think it's
good company. I think if you
live in a rarefied, marvelous
atmosphere, you're happier.

It always takes
more than money.
It can't be *just* money.
Listen, money helps everything.
It helps you get breakfast in bed
so you can get up
a little more calmly.
Being *chic*, running a *house*,
having a *beautiful* house—
no money in the world
can produce that.
There's got to be a mind
and a dream behind it.

Every day you *must* have a new opinion or a new point of view. I can remember when I discovered painting.

I went absolutely *berserk*.

I'm still a little maniacal about new things that happen to me, you know—I sort of think how *gorgeously glorious* this is— like finding myself walking around Red Square in the middle of the night . . . with this wonderful basilica behind me and the onion domes. *So beautiful.*

Then I become maniacal again.

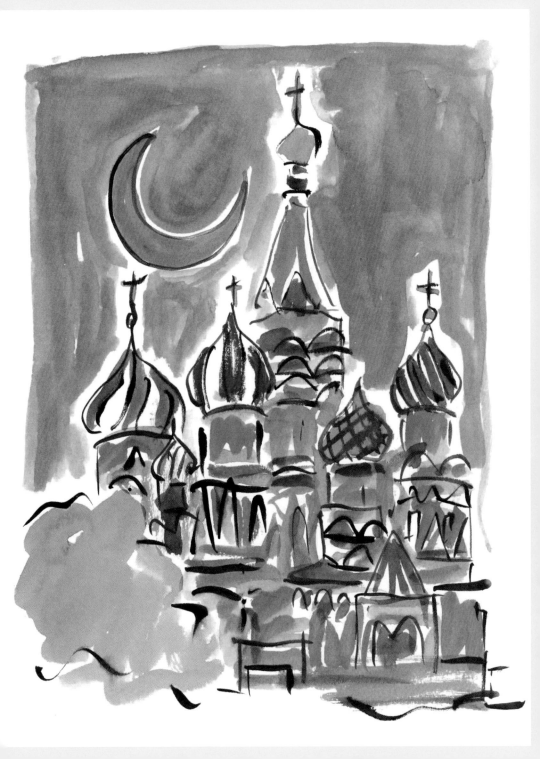

Whenever you're doing anything, if you do something else—stretch! In your spare moments, stand against a door—like your bathroom door—and press your spine against it. It pulls everything in your body into place. Everybody should do this.

I believe in back-cracking!

I'll crack your back,

but you have to crack mine too.

This is a rather strict rule with me.

I practice it with my grandsons all the time.

My favorite
day of the week
is Monday.
The concentration
that hard work brings
will take you
a long way.

A good massage— that's what I believe in! My dear, it's the ABC.

Power has got to be the most intoxicating thing in the world—and of all forms of power, the most intoxicating is fame.

The hula's
a marvelous
dance to know.
It's divine
because it goes
with the breeze,
with the palms—
it's the rhythm
of the waves
and the trees.
It's got a rhythm
and rhythm's
the thing to have.
It's hard
to do right,
but then everything
is hard to do right—
you've got to learn.

People would tell me fashion started in the streets, and I would say I saw it first at Balenciaga.

There is nothing dowdy about Princess Diana.

She's got radiance. What she wears is incidental,

but she has wonderful taste. Aura is everything.

It's the essence of the woman.

You can buy the town out and not get off the ground;

but if you've got the personal aura, you just shine, you give pleasure.

8

Mick, Jackie, Cher...

I loved when you

smashed

my chandelier

and I loved

the boxes of flowers

the next morning.

– To Mick Jagger, 8 August 1983

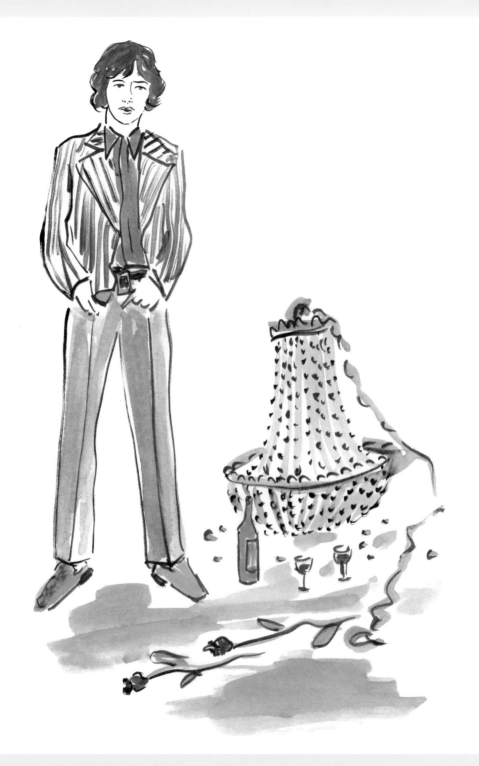

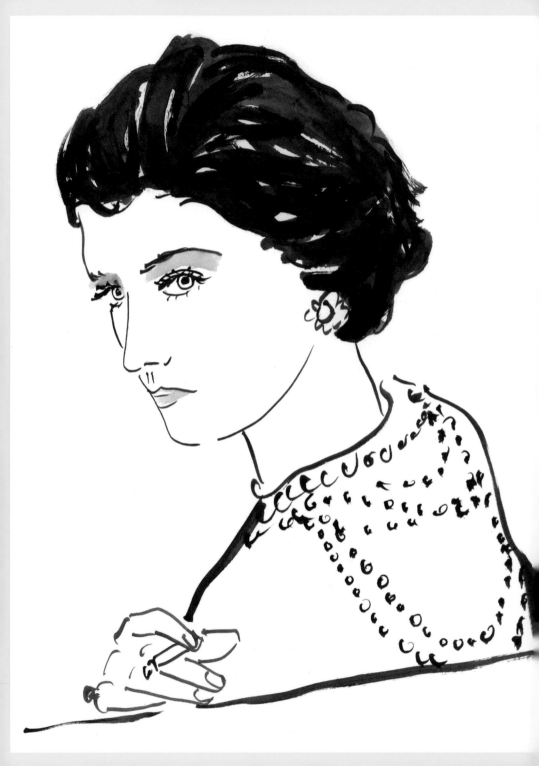

Coco
Chanel
had the
expression
of a baby
bull dressed
as a Prussian
sailor.

And then
she stopped.
Greta Garbo stopped
like a horse
might stop
in the middle of a race
and never run again. . . .
Why did the horse stop?
There isn't
an answer to that.

It's become a test. I've concluded that anyone who thinks Barbra Streisand is vulgar *doesn't understand one thing.*

He also has a fifty-fifty deal with the street. Half the time he's inspired by the street, and half the time the street gets its dash from Yves Saint Laurent.

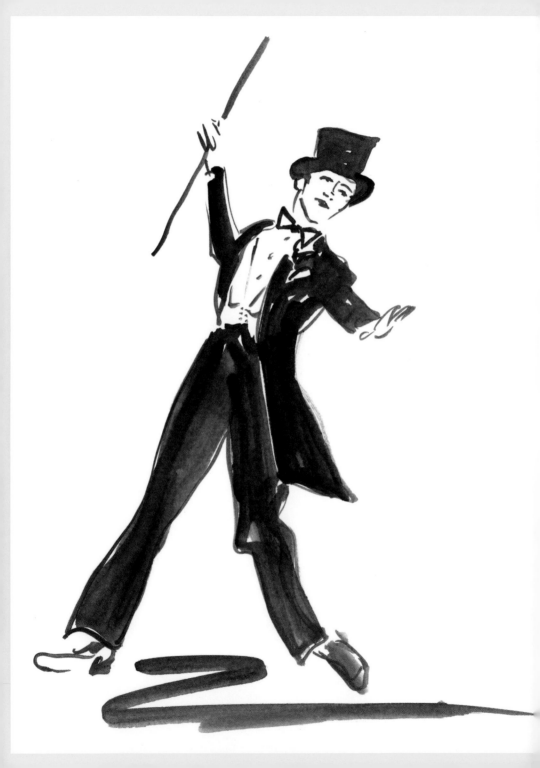

Dear Fred,

We are so very, very seriously upset about white tie and tails and shoes, described in my letter to you of April 7.

We really care terribly about having this costume in our show, as we will have all sorts of wonderful clothes identified with dancers, for instance, the costumes of Irene Castle and Josephine Baker.

Of course, I have to take your word for it, but I cannot believe that these have disappeared off the face of the earth, as they are the incredible symbol of the era which you alone created, and I also cannot imagine that anyone would wear tails today.

Can I bargain with you? Perhaps you have the top hat, white tie and pants, shoes, cufflinks, etc., and not the jacket, and this would be very chic with the top hat—very racy and very attractive, I am sure you can easily visualize what I mean. There is nothing as romantic as when a man is dressing for dinner, gets so far, and then puts on his top hat.

Would this be possible to do? Have you got any suggestions?

I so look forward to hearing from you again.

 Diana Vreeland

– Letter to Fred Astaire, 5 May 1986

It's Jackie Kennedy who released style in this country. *How?* I can't tell you how she did it. Except that she did, because when she went into the White House and put a little style into it and into being the First Lady of the land . . . *suddenly good taste was accepted as good taste.*

I wish I could give you a load of
Clark Gable's eyelashes!
He had the most beautiful
eyelashes I've ever seen on a man—
on a human being.
They were exactly like
a Shetland pony's.
Now you're probably not as intimate
with Shetland ponies as I am—
they have the *longest,*
fuzziest eyelashes
of any creature you've ever seen.

Don't you think
that you should
do some wonderful
war paint on Cher's
back—divide her
glorious hair
and show her
marvelous skin
and do something
amusing in the
bright light of the desert.

I don't notice the pace. I just notice New York.

When the parts are right, there's nothing more beautiful in the world than the face of a Russian woman.

9

I Love the City

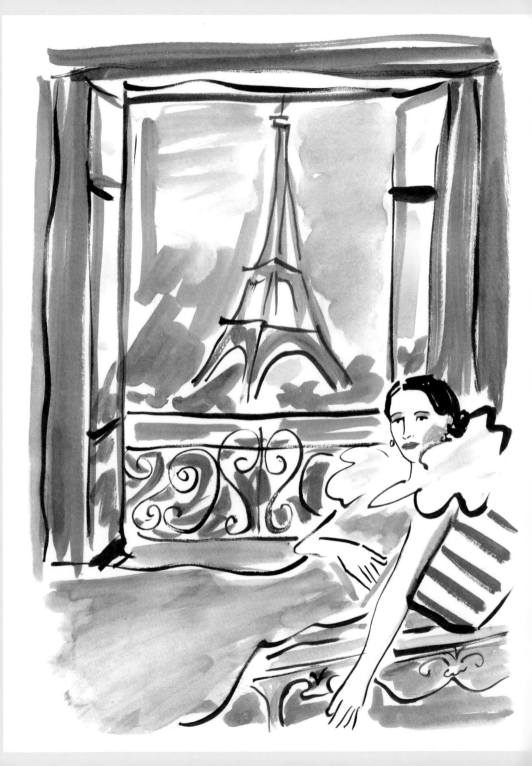

French women are a different breed of cat. Remember what Napoleon said to Josephine?
Go to Paris and become a woman!

My parents had a great sense of style and I was born and brought up in Paris, remember that. You can say, "What difference does that make?" It makes all the difference. People who are born in Paris are a little different. It is a fact that people there are more interested in those sorts of things. Then once you have that standard, you must maintain it.

The first thing
to do, my love,
is to arrange
to be born
in Paris.
After that,
everything
follows
quite naturally.

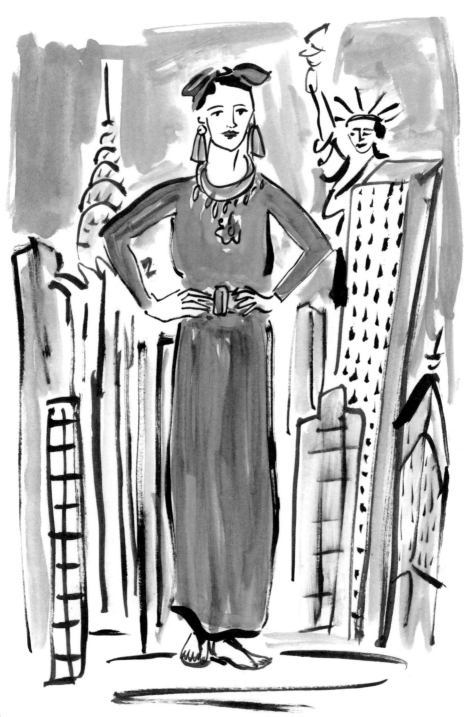

I would only like to live in New York. There's a great variety. The world comes to New York— it's the central hub. Of what? I do not know. But it seems to be the center of *everything.*

The
best
thing
about
London
is Paris.

God was fair to the Japanese. He gave them *no oil, no coal, no diamonds, no gold . . .* Nothing comes from the island that you can sustain civilization on. What God gave the Japanese was a *sense of style.*

What I had in mind were the girls of Naples, with their *fire and frolic* of dancing and moving their arms and tambourines up and down. I thought they presented *so much joy and fun*. And when they were through with a dress, they probably used it to clean out the cellar.

Italy has enormous,
enormous style.
When a stone rolls
loose in Italy,
it arrives at exactly
the right place.
The Italian women
have the physical allure
that no nationality has.
There is a natural rhythm there
and it starts in the beauty of the people.

New York is victorious.
It is neither the capital of a country,
nor is it a perfect place to live.
It's got its own way of seducing
and keeping the seduction flowing
freely because it is New York.
Somehow or other, it beats the rest
of the big cities because it seduces
the world. *It is too crowded and stuffed*
with too much, but there is a wonderful
fresh air that blows through and
around it off the Atlantic.
Sometimes this air is hard
to find, but it is there
and keeps us all alive.

St. Petersburg is the
most beautiful big city
I've ever seen in my life!
It was bigger than life.
I mean, it only has
forty square miles
of pink, mauve, lavender,
pistache green and
pale blue palaces,
all of such a nobility,
such a scale . . . wide,
wide avenues and squares
. . . nothing but rivers and bridges
and sunsets and clean,
clean northern air.

**I can always see China.
Any place you put me,
as long as there is
nothing in between,
I can always see China.**

Don't discourage anyone who wants
to go to the country. You can't spend
all your life on the cement and
pavements. I love the city. I have never
lived anywhere else except the city.
I love waking up in the country, don't you?
Oh, you don't give a damn!

– Conversation with Andy Warhol, 3 January 1979

Lettuce is divine, although I'm not sure it's really food.

I never remember anything unpleasant.

Details are in the Imagination

Now I exaggerate—
always. And of course,
I'm terrible on facts.
But in a good story,
some of the details are
in the imagination.
I don't call this lying.

**Truth is
a hell of
a big point
with me.**

Most people
haven't got
a point of view;
they need to
have it
given to them—
and what's more,
they expect it from you.

I'd rather be airborne
than anywhere else.
The sky is really my spot,
and once I'm up,
I find it infinitely hard
to come down.
If I had my way,
I'd be forever sailing
through the blue celestial.

You know, there's nothing as dead as a dead love.

**I never believe anything
I see in a painting.
Think of what they
would have done with me.
I would have been
the greatest beauty of the age!**

I love dressing for dinner.
I always thought the night was
sort of a fairy-tale world,
extraordinarily attractive.

I'm sure
I chose
to be born
in Paris.
I'm sure
I chose
my parents.
I'm sure I chose
to be called Diana.

I write so badly
and I can only express
myself in ungrammatical
sentences without
beginnings or *ends*
as all the meaning
is in the *middle*.

It is for you to discover for yourself, within yourself— within the *silent, green-cool groves* of an inner world where, alone and free, you may *dream the possible dream*: that the wondrous is real, because that is how you feel it to be, that is how you wish it to be … and *how you wish it into being.*

1 Allure

Page 8 "Allure holds you", *Allure*, by Diana Vreeland (with Christopher Hemphill), Doubleday, 1980, pg. 11; "Allure... is something", *Allure*, pg. 11; **Page 11** "The world without", Interview on *The Dick Cavett Show*, May 5, 1978; **Page 12** "I think the", Draft for *DV* by Diana Vreeland (edited by George Plimpton and Christopher Hemphill), Knopf, 1984; **Page 13** "I'm mad about", From personal papers, 1978; **Page 14** "Elegance is innate", *Allure*, pg. 203; **Page 16** "The trouble is", Quote from *Young at Any Age: Thirty Three of the World's Most Elegant Women Reveal How they Stay Beautiful* (Ira von Furstenberg, Littlehampton Book Services, 1981), reprinted in *New Woman*, Nov/Dec 1981; **Page 17**, "A little bad", *DV*, pg. 122; "I think things", "Homage to Vreeland" by David Livingstone, *Toronto Life Fashion*, Winter 1980; **Page 18** "To me, the", Quote for *Courvoisier's Book of the Best*, edited by Patrick Lichfield, May 28, 1986 ; **Page 20** "Do you notice", *DV*, pg. 161; **Page 21** "Extravagance is everything", Draft for *DV*

2 Never Young, Never Old

Page 22 "The great days", Draft for *DV*; "Don't think you", *DV*, pg. 43; **Page 24** "I am not", Letter to Ann, January 24, 1971; **Page 27** "Remember, activity is", "Top Fashion Expert, Still Going Strong at 75, Says You Must Keep Up With the Times," *Modern Maturity*, 1975 ; "I've never felt", Quote from *Young at Any Age*; **Page 28** "You have to", "Top Fashion Expert ...", *Modern Maturity*, 1975; **Page 30** "People say elegance", "Vreeland: Staying Power," article by G.Y. Dryansky announcing Mrs. Vreeland leaving *Vogue*, *WWD*, August 20, 1971; **Page 31** "I never want", Quote from document on Horst, "The quickest way", *Modern Maturity*, 1975; **Page 33** "I think when", *DV*, pg. 25

3 The Color of the Inside of a Pearl

Page 34 "Lighting is everything", *DV*, pg. 104; "Black is the hardest", *DV*, pg. 105; **Page 37** "Yellow! You don't", Draft for *DV*; **Page 38** "Pauline de Rothschild", *DV*, pg. 105; **Page 39** "I would like", Letter to the fashion designer Mme. Grès, October 28, 1974; **Page 40** "It is important", Memo to *Vogue* staff, June 30, 1969; **Page 42** "I love the", *DV*, pg. 104; **Page 43** "All my life", *DV*, pg. 103; **Page 45** "Actually, pale pink", *DV*, pg. 106; **Page 46** "I think it", Letter to Marthand Singh regarding the preparation for the *Costumes of Royal India* exhibit at the Costume Institute of the Metropolitan Museum of Art, April 22, 1985; **Page 47** "I loathe red", *DV*, pg. 103; **Page 49** "About the best", *DV*, pg. 103; "Red is the", *DV*, pg. 103

4 Creative Thinking

Page 50 "I'm accused of", Draft for *DV*; "I'm a great", *DV*, pg. 122; **Page 53** "Oh, I am", *DV*, pg. 103; **Page 54** "I think it's", "A Phone Call From DV, Diana Vreeland talks to Brooks Peters," *Vanity Fair*, November 1985; "Anybody who

Fashion and Style

Footnotes

Getting Around Corners

8 Mick, Jackie, Cher...

Page 108 "People would tell"; "The Era of Balenciaga: It Seems So Long Ago" by Bernadine Morris, *New York Times*, March 23, 1973; "There is nothing"; "Fashion Experts Rate Princess's Style" by Michael Gross, *New York Times*, November 13, 1985; **Page 110** "I loved when", Quote for book on Mick Jagger by Brooke Hayward, August 8, 1983; **Page 113** "Coco Chanel had"; "Vreeland: Staying Power," Dryansky, *WWD;* **Page 114** "And then she"; "A Question of Style, Diana Vreeland," Weymouth, *Rolling Stone;* **Page 115** "It's become a", Draft for *DV;* "He also has", Telegram to G.Y. Dryansky, December 16, 1981; **Page 117** "Dear Fred," Letter to Fred Astaire, May 5, 1986; **Page 118** "It's Jackie Kennedy"; "A Question of Style, Diana Vreeland," Weymouth, *Rolling Stone;* **Page 121** "I wish I", *DV,* pg. 142; **Page 122** "Don't you think", Memo to Babs Simpson at *Vogue*, March 12, 1970

9 I Love the City

Page 124 "I don't notice", *Toronto Life Fashion*, Winter 1980; "When the parts", Quote in article by John Duka for magazine article entitled "Détente Dressing"; **Page 127** "French women are" , Draft for *DV;* "My parents had", From personal papers entitled "When I was a child," 1978; **Page 128** "The first thing", *DV,* pg. 196; **Page 131** "I would only" Quote for *Courvoisier's Book of the Best ;* **Page 132** "The best thing", Unknown; **Page 135** "God was fair", *DV,* pg. 26; **Page 136** "What I had", Letter to costume designer Umberto Tirelli, July 20, 1986; **Page 137** "Italy has enormous", Draft for *DV;* **Page 138** "New York is", Quote for *Manhattan: An Island in Focus* by Jake Rajs, Rizzoli, 1985; **Page 139** "St. Petersburg is", *DV,* pg. 184; **Page 140** "I can always", Draft for *DV;* "Don't discourage anyone", Conversation with Andy Warhol on January 3, 1979 (Barry McKinley, John Boz Lyons, and Bob Colacello were present)

10 Details are in the Imagination

Page 142 "Lettuce is divine", *DV,* pg. 157; "I never remember", Draft for *DV;* **Page 145,** "Now I exaggerate", *DV,* pg. 158; "Truth is a hell", DV, pg. 158; **Page 146** "Most people haven't", DV, pg. 150, discussing her role of editor in chief of *Vogue;* **Page 148** "I'd rather be", *Travel & Leisure*, December 1982; **Page 149** "You know, there's", "A Question of Style, Diana Vreeland," Weymouth, *Rolling Stone;* **Page 151** "I never believe", Draft for *DV;* "I love dressing", Quote for an interview, 1972: **Page 152** "I'm sure I", *DV,* pg. 196; **Page 153** "I write so", Quote for book on Mick Jagger by Brooke Hayward, August 8, 1983; **Page 155** "It is for", *DV,* pg. 173

Back Cover "I believe, you", "A Question of Style, Diana Vreeland," Weymouth, *Rolling Stone*

Acknowledgments

This book came together thanks to my wonderful collaboration with the illustrious art director, Sam Shahid, his remarkable designer Matt Kraus, and my talented editor, Caitlin Leffel. This is the second book that I have created with Sam and Matt. Drawing on the style of Alexey Brodovitch, we worked to give the book playful yet disciplined layouts. Each quote was carefully considered—as well as its placement, the typography used, and its juxtaposition with the rest of the quotes and artwork—to achieve the cadence of the book. I'm also thankful to Caitlin for making sure that we tightened the text and added italics for maximum impact. This is our third book together and I so appreciate her participation.

Sam suggested that we work with the young illustrator Luke Edward Hall. Luke succeeded in channeling all the artists that my grandmother worked with while never losing his distinctive colorful hand. We asked for twenty illustrations and he gave us many times that amount.

My friend and literary agent, Andrew Wylie cheered me on; thank you! And my thanks to Charles Miers, the publisher of Rizzoli who believed in this book and gave us the resources to make it possible. He diligently pushed the layout to be more readable, understanding the appeal of the quotes.

Many thanks to Julie Muszynski who scoured the files and boxes at the New York Public Library, the Metropolitan Museum of Art, Condé Nast, The Warhol Foundation, and anywhere else we thought there might be treasures to discover.

My thanks to my son Reed who helped me write and sharpen the introduction.

I dedicate this book to my brother Nicky who went over the layout page by page, word by word, and asked me to polish some illustrations and tighten quotes so that one could hear my grandmother's voice, one which he may have known better than any of us. Nicky moved to New York in 1973 and spent the next eleven years at my grandmother's side. He was the only family member who fully participated in her "Met years." Nicky went to her Costume Institute openings, accompanied her on trips and to nightclubs, lived in her apartment at times, and made sure that she had the support and love that she needed. Those years were transformative for him as he prepared to become a Buddhist monk, and invaluable for her as she became more dependent on a trusted ally. I was able to dig up some of their correspondence, which reflected the great love and fun that they had together. In 1985, when Nicky was commencing his monastic studies, she wrote him a letter that started: "Nicky: My Darling Angel Face Squab. My Angel: They might not know you in Tibet as a Squab, but to me, you are a squab."

I thank my wonderful children: Reed, Diane, Victoria, and Olivia. Their support, counsel and encouragement are invaluable to me in whatever I do. I am blessed to have a father whom I am closer to and am in greater harmony with than at any time in my life. Freck has been a source of constant love and has a strong confident hand on my back. I am so fortunate to have Lisa—my great love—at my side.

First published in the United States of America in 2020 by
Rizzoli International Publications, Inc.
300 Park Avenue South
New York, NY 10010
www.rizzoliusa.com

© 2020 Alexander Vreeland
Illustrations by Luke Edward Hall

Publisher: Charles Miers
Editorial Coordination: Caitlin Leffel
Designed by Sam Shahid
Art Director: Matthew Kraus
Production Manager: Kaija Markoe
Managing Editor: Lynn Scrabis

Printed in China

2020 2021 2022 / 10 9 8 7 6 5 4 3 2 1

ISBN: 9-780-8478-6471-3

Library of Congress Control Number: 2019946738

Visit us online:
Facebook.com/RizzoliNewYork
Twitter: @Rizzoli_Books
Instagram.com/RizzoliBooks
Pinterest.com/RizzoliBooks
Youtube.com/user/RizzoliNY
Issuu.com/Rizzoli